Listening
For
Cactus

LISTENING
FOR
CACTUS

by

MARY MCGINNIS

Judy appeared in A Room of One's Own. "Listening For Cactus" was anthologized in *Saludos* (Pennywhistle Press). "Mrs. Green Mummy" was published in *Santa Fe Arts Advocate*. "Our First House" appeared in *Dialogue*. "Reading Braille" appeared in *Womyns Braille Press Newsletter*, *Disability Rag* and was anthologized in *The Ragged Edge* (Advocado Press) and *New Mexico Renaissance: A Community on Paper* (Red Crane Press). It is scheduled to appear in *Bookworms*, an anthology about reading. "Tenderness" appeared in *Private Stories on Demand* (Moving Woman Press) and *Slate and Style*. "To Think about Tiredness" was published in *Ecolife Newsletter*, *Womyns Braille Press Newsletter* and *Signals*. "Wild Pears" appeared in *American Land Forum Dialogue*, *The Archer* and *Feelings*. "Seeing" was anthologized in *Range of Motion* (Squeaky Wheels Press) and appeared in *Private Stories on Demand*. "Patience" was published in *Private Stories on Demand*. "From my Eyes" appeared in *Womyns Braille Press Newsletter*, *Woman of Power* and *Journal of Progressive Human Services*. "Crossing Over" was published in *Slate and Style* and in slightly different form in *The Eleventh Muse*. "Hot Weather" was published in *Up Against the Wall, Mother*. It was also featured in the Women's Recovery Show Catalog in Santa Fe. "Where I Come From" is scheduled for publication in an upcoming issue of *Are We There Yet?* "Her Natural Condition" was published in *Signals* and *Womyns Braille Press Newsletter*. "When I'm Eating Chocolate and Writing" was published in *Written with a Spoon, A Poet's Cookbook* (Sherman Asher Publishing). "The Woman Who Is a Writer" appeared in *Private Stories on Demand* and in *Signals*.

Cover design by New Grub Street graphic design
Photographic images by Chris Corrie Photography
Book design by Judith Rafaela
Design consultation by Janice St. Marie

ISBN 0-9644196-4-5
FIRST EDITION

Library of Congress Cataloging-in-Publication Data

McGinnis, Mary, 1946-
 Listening for Cactus / by Mary McGinnis.
 p. cm.
 ISBN 0-9644196-4-5 (trade paper : alk. paper)
 I. Title.
 PS3563.C3642L57 1996
 811' .54--dc20 96-30940
 CIP

Sherman Asher Publishing
PO Box 2853
Santa Fe, NM

For Steve with love and thanks for his encouragement of my writing—through all those many delicious meals and dishes done so I could take the time to write, as well as outrageous writing assignments we've given each other, and the space we have created together.

To all the women I have ever written with, poets and not-poets, and those who have inspired and appalled me.

Thanks to Judith of Sherman Asher Publishing for her expansive vision, and Nancy for her lively way of being an editor and encouraging me to meet deadlines.

CONTENTS

▼

VOICES

HOW IT WAS IN A DREAM

SHIELD OF LEAD

A Strange Taste on My Tongue

Spells

VOICES

Chinese Woman Smoking

Now that I'm old,
the oolong slides down my throat;
my teeth are gone
along with the sharpest memories of pain.

My children continue to fight
in far off corners of the house:
they are merely crows,
talking in a foreign language.

My daughter-in-law still wants a child.
She practices her characters
with the most delicate of brush strokes,
hour after hour

until her fingers are swollen
with trying too hard.
I give her an amulet
when she brings me a bowl of rice,

I tell her the moon is full of extra children,
to get one from the moon;
she walks away with downcast eyes.
I smile to myself. What difference will it make

if there's one less child in the world? My son
will frown darkly and beat his wife until she shines,
but the moon will still drop seeds on the water,
and I will sit up until dawn,

counting the bird claws of my toes.
Now that I'm old,
I'm bathed in blue light;
it makes shadows I don't peer into.

I'm rocked slowly into dream,
a lily pad in the pond
of endless, circular existences.
What difference does anything make?

ISADORA SPEAKING

When I die, give away my silver sandals
to the children; tell them I loved their ankles
and sent them electricity from my solar plexus
to make them strong.

Cut up my brick-red dresses
into so many flags. Pass them out
to the whores parading outside of cafes.
Cut out the smallest bones in my feet—

make them into subtle necklaces and rings.
Send one of each to each of my lovers who is still
living. Sprinkle the dust from my ashes
onto the graves of those lovers who are dead.

Stand in drizzling rain and think of me as I was:
lithe and sparkling, wearing blackbird feathers
in my ears. Once I'm dead, send singing
telegrams to the people to whom I still owe money.

Sing to them she's gone now, she's left nothing
but wild and extravagant movements to her friends;
no money, no furniture. No fur coats.
No diamonds. No coal for the stove.

MOON FLOWERS (FOR JOY HARJO)

Tell me about the night you met the moon
at a bar in Iowa City—
what she was wearing, whether or not you could look at her
without shivering and burning at the same time,
whether looking at her hurt your eyes.

Tell me about the moon's breasts,
what language you spoke to each other,
her accent, her jewelry, her makeup,
who else noticed
when she leaned forward and tucked a silver flower
into the dark hair behind your left ear.

Tell me what you were drinking that night,
how many drinks you had,
and how many people became uneasy
because of the moon's presence.

Tell me about leaving the bar by yourself, staggering,
explain the strange markings on the deep snow,
the rip in your coat,
the sky empty of stars,
the catch in your throat,
the scales of several large fishes
glinting on your porch,
and how you felt when you turned on the radio
and heard the nasal, mid-western voice of the radio
announcer saying it has been reported by reliable sources
that the moon has been missing from the sky
for the past several hours.

Describe how you calmed yourself down
and slipped into a fitful sleep
until your children shook you awake
with their bony fingers blue with winter.

Tell me that you didn't remember walking home,
or what time you had to go to class,
or who might have taken your last cigarette;
I want to know what else you forgot that day,
about your glazed eyes,
and what your friends said to you when you told them
last night I dreamed
that the moon and I were drinking whiskey together
and that we told each other
dozens and dozens of white lies.

PATIENCE

i want to write so fast i can't read any of it,
i want to have spasms in my mouth so that you can't understand
a thing i say—
echolalia, perseveration, dyspgraphia, *poo* and *boo*
and *opadopybop*, i am not a patient person,
i like my steak rare, i don't like that tantric yoga sexual position,
it makes me nervous, i like the talking heads,
i eat chocolate pudding out of a can, i only have one telephone,
i don't like wires in my way,
i hate coffee tables in the middle of living rooms,
i won't take the time to read maps,
i like friendships that start quick
like battery operated lanterns and gas fires,
and when they're over, i like to break things off cleanly,
i have an unlisted phone so that salespeople won't bother me,
i hate people who stutter and can't spell and mispronounce things,
i could grind my teeth,
sometimes wake up with an ache in my arms and legs
because i was trying to get somewhere in my sleep and couldn't do it
 fast enough
i'm picky like my mother was at the dinner table: put the napkin on
 my left,
don't talk with your mouth full
i found out i can yell and slam things and call people stupid like my father,
i could intend to work on this problem: tonight, tomorrow, next week,
i can hurry it up and send myself into the orbit of patience
where i will go round and round, getting colder and colder
until i freeze to death in the sacrificial position of repose,
i could ask myself, i could ask myself to mark a date on my calendar,
deciding when i'll start
but i'll do nothing of the kind.

MIDDLE-AGED WOMAN TALKING TO HER FIRST LOVER

Thinking about when we were young—
and how we fought—
I speak in sun-fire,
my tongue too hot to hold.

Twenty years after it ended,
I'm ready to begin it again.
Come, drink apple tea with me,
herbs flavored with cinnamon and star anise.

Come to my loft in the country;
we won't need wine—
we never did.
There are places inside my body that will remember you,

mysterious grasses
exploding and melting into fountains.
Come toward me,
wearing your sophistication the way you always did.

Let me taste your worn mouth.
Notice my red-brown hair—
it glistens in the sun like the rivers of perspiration
we used to swim in.

I never wanted your name—
just the chance to take you on and undo you,
the chance to match you in your quest for pleasures,
the chance to flood each other with light,

the chance to bury each other.
Let's bathe each other
before the wells are poisoned,
and the grasses shot down by cyanide.

Let's have this one afternoon,
where we grind into each other's wings,
and become one bird-form that sheds its feathers,
and flies into the next world.

Woman Talking to Herself and Drinking Tea

she says to herself: you've graduated.
the school of suffering and hard times has thrown you out
without a diploma; your name has been erased
from the Great Book of Pain, the picture of your
sunken, concerned face removed from the yearbook;
your "A" for agony has been stricken from the rosters of the sad,
your transcripts soaked in tear gas.
no one except your closest friends
needs to know you wallowed in misery, sticking your hands and chin in it
like it was the icing of a chocolate cake.

you told the instructor of guilt *i'm going now,*
not looking back; this ramshackled hag of a teacher
with cold oozing fingernails heard you and is letting you go.
from now on you will have the normal pains that everyone has,
a bad day, an hour or so of crankiness.
you are free as a pigeon in the plaza, beautiful
as the swan that sleeps on the glossy pages of a fairy tale.
you will weep now and then when you make love,
you will think of your past and feel that sadness
slowing you down like high-heeled shoes,
but you will step out of that sadness, letting its fragmented beauty
rise and settle on your hair. you will get out of the circle
of what you thought you were and rise and float and come to rest;
you will laugh and touch the soft shape of yourself,
the curves, the hands that curl like kittens
around your steaming cup of tea.

MOTHER AND DAUGHTER

Where are you?
Where are you?
I'm
your mother.
Are you
in the lettuce?
Are you eating
the lettuce?
Are you a
nasty
piece
of a
bug
wiggling
like a snake?
Hold still,
hold still.
I am
threading my
needle.
Stay
where you are.
I will
haul
you up
on lines
of unbreakable
thread.
You were
never
my child,

I'm the bug
baby.
The color
of moles
dark red
tar. I cry
out of tune, just
one note, my voice
a piece of devil chalk,
a cricket with one leg
moving back and forth
in thick fog, scratching
at the bottom of my mother's
refrigerator. Help!
I'm freezing to death
my hair sticking
to the shelf, my body
in a bag
of apples,
green with
cold . . .
I am your
round child,
your half dollar,
your second prize.
Help!
I am
losing my
balance.
I am your
bug child,

never
meant
to be
mine;
you were
a piece
of dark,
dotted cloth
I brought in
with the
paper.

your hungry
child.
You are my globe,
my princess.
Let me out.
I am humming
in your hum,
I am scratching
out a living
among the miscellaneous
pieces of onion skins.

Woman Eating Some Birds

I inhale deeply,
rapture playing with my ears.
The body of my pipe, black and smooth
as the velvet of lukewarm tea.
It fits into the curve of my fingers,
a bird disguised as a pipe;
I purse my lips. The bones
of the birds I devour
are warm and cool at the same time—
my mouth full of oil and feathers.

Burnt beyond Recognition

The fire of my life as it has been:
pieces of plywood, lighter fluid's clear poison,
plastic bags full of holes,
torn paper on which I dreamed
and listed my sins, my mother's wail
in the night which I never heard as a child—
bending at the fireplace,
with the chimney belonging to the demons,
I strike a match, I throw it into the center,
I torch the sticks that drank up shadows—
an explosion of hate that goes up in flames.

Surrounded by a mist, a white lion
is walking a foot above the ground:
I jump on its back,
it carries me away,
leaving grief's black hood behind.

I'm the feather of a bird
lodged between tree branches,
and the mothering bird who lost me
comes back for me and I fit under her wing.

Believe me: I was never a child-woman,
I never lived in the twentieth century,
ate potato chips or typed on a manual typewriter;
I never had the urge to write,
the nighthawk never came
at the end of the sunset,
I never sang or got lost,
I never screamed at you,
and you are never going to die,
and I am never going to grieve.

If the ocean didn't fill up with needles,
and if the snakes didn't dance,
then I have never told you the truth,
and this fire was never a fire,
and our blighted star
will last another billion years.

THE SECRET LIFE OF MY MOTHER

To be inside that hummingbird body and not explode outward, I
hold myself still as the dead moon. Slowly I have
expanded in darkness, against the curve of pelvis,

segments of bowel. I have pressed myself into
existence without a
could-I-please; taken
root in there, blood-brown flower,
excrescence of despair,
tumor of terror, without a by-your-

leave; I have wormed my way, I
infiltrate, I grip. I am not
friendly but I have travelled
everywhere: I have been

on fleas, on fire, for
free. Twisted, I am common as

mud. I can live in a woman for thirty
years. Perhaps she felt me

moving in her sleep like a pearl of poison in an
old nightmare. Prepare yourself, I
telegraphed through the blood, but she turned away,
her eyes open in sleep, sleepwalking to the
edge thirty years later. Now we will not be ripped from each other.
Even in death.

THE DEAD WILL GIGGLE

No cure for my depression—
ever-present like formaldehyde and mice,
I wear it like an ear cuff, I stir it
into my morning tea, I chew it,
I paint it on the roof of my mouth, I pack it
into invisible styrofoam take-out containers
and give it to my friends.

Here, take it, I say, let it eat
another corner out of your ozone layer,
not mine; let's pretend it tastes good.
Let's pretend it's very expensive, let's agree
to drink depression together, and get circles
under our eyes, and a rash.

No cure for depression—but a long afternoon
staring into my own well—
a good read in the "Can This Marriage Be Saved?"
column in *Ladies Home Journal*
and a story about a lost child to make me cry. After that,

my leprechaun self will step up behind me and say
you're not so bad; you can cry
and the arroyos will not wash away
and the bitterness you feel for the people you despise
and the stupid things they do will disappear,
when you return to the garden from your first tears—
there you are bathed in New Mexico pine
and sand scents, and besides, it's almost Halloween,
and the ghosts will swish themselves between cactuses,
and the dead will giggle at you when you suffer too much.

If there's no cure for depression,
I know there is also no end to the purple flowers
that will bloom next September
along the access roads off of Route 14;
in mid-October, there are still a few of them left.
I will go out onto the porch and start listening for the dead.

It's Your Hand

We used to talk about the candies we loved as children;
tonight we talk of abortive dates,
failures that kept repeating themselves

until we met and held each other steady—
"Lynn," you said, "Oh, her;
just a housewife wasting time with me.
There was only that one time
I went to her house in desperation—
and nothing much happened there really.
It was only you I drove down
Route 422 to see on lunch hour,

you I would hold on the grass carpet."
You might be right, I think,
amazed at the flowers of memory you toss me:
how the night we met
we stood under the big tree on my street,
and I said, "Don't say goodbye yet,
and call me next week before I leave."
And I don't remember that as much as us

buying our first hiking boots together,
and you writing the poem about our folding sheets,
doing the laundry in Audubon.
This is tantric conversation. Lying here for hours
lost in stories, our breaths smelling of milk and clean—
your hand on my forehead with the faint, sweet aroma
of sleep on the palm—I forget you've been in pain,
I forget that radiation from above this town

is gnawing on our bone mass, making us shrink.
"I love the leaves outside," you say,
"the moon, our bellies in repose." "It's your
hand," I say, "it's your hand in repose."

Hot Weather

there's hot weather in a woman's house
hot weather
when she wears her anger
like an ill-fitting polyester shirt
until she sweats
her throat tightening with whispered threats
unless she raises her arms shouting
standing on chairs
terrified
telling those she loves she is powerful

i feel my anger like a caged moth
dazzled with light wanting to break out:
the sharp sentences i use
smothering in politeness
those bright and ugly creatures
struggling to push through glass

a woman full in her anger
does not need words
self-evident as fire or sun
i picture her changing cities like a bomb

i do not cross the desert of my pain alone
i push myself out there
it's 100 degrees
i'm getting stronger
trembling in the heat

The Woman Who Is a Writer

wears a warrior's shirt
made of roses and shadows
the little dragon of her mouth
has swallowed many a secret thought
at times they flutter
out of her eyes like moths
she may look at you then
as though she has a wound
that will never heal
late at night alone
she becomes delirious
and longs to eat stars
she stares into the glazed white face of the moon
demanding that beauty and madness be explained to her
tomorrow she may drink strong elixirs
and speak in riddles
she will sleep on white stones because her spirit is bird-like
born to suck on her dreams and find them sweet
she wants to find out what taps at her in her dreams
she likes to sit in the long gown of her skin
waiting for the snake of fantasy
without doing anything
or to write until she is too tired to eat
or forget she has a voice
while writing and writing
in overheated rooms of houses that are falling apart

HOW IT WAS IN A DREAM

NOT BEING ABLE TO STOP

Being brought up Catholic,
I heard about various saints
who weren't able to stop—

Joan of Arc
whose hair and clothes burned so brightly
she set the hills on fire,

her breath causing trees
to sigh and bend—

and burst into flames;
she was tied to a horse of brown sticks,
she rode out into her own illuminated night
and couldn't stop herself, her horse,

or her bulging eyes;
then there was Bernadette:
she stood out in the cold until her feet froze;

she watched for the Virgin
in the crevices and the thorns
long after the snow stopped falling,

and the moon shone
like a scepter of stricken, queenly flesh.
There were male saints and others

who couldn't stop
but it's the women I remember
and the womanly Christ and Mary Magdalene

who couldn't stop being a fox,
and Mrs. Murphy my fourth grade teacher
who stamped her feet every other day—fast—

and couldn't stop yelling,
and my mother who wasn't even raised Catholic,
who couldn't stop loving my father.

She gave up cigarettes and coffee
but she continued to love my father
with a vehement, determined Germanic love

which terrified him
when he wasn't too drunk
to know that she cared for him like an octopus, like an iron maiden.

It doesn't surprise me
that I can eat a whole box
of Godiva chocolates in an evening,

that I can write and sit in the sun
without moving for a long time,
that I like excesses in Gothic novels,

and that I do what I do
because there may not be a tomorrow.
I remember how it was in a dream

where I rode Joan of Arc's horse
until it turned to skin and bones
and wouldn't get up again, no matter

how long I cried,
and pulled on its rope
and spoke to it in halting French.

Dreaming about Nothing

I hate how I don't remember my dreams.
It's as though I were Persephone:
heading for the underworld on a shiny black elevator
made of volcanic rock.

Instead of looking around her,
she reads comic books by flashlight.
She hears her mother calling over the clacking of the underworld machinery:
"Did you pack a scarf, waterproof boots,

a needle and thread?"
She puts earplugs in her ears,
listens to the sea of sleep in her head,
she sinks down through mists, looking to neither right nor left.

I wear socks so my feet won't get cold;
I read in bed, books that are politically correct:
nothing too violent or sexual.
In the morning the electric buzzing of the clock

splits my dreams in two; the walls of my bedroom
too rough for dreams to stick to—nothing
beeps in my ears. I hear my heart beating
with my hand but never find out who was chasing me.

I think of the day, neatly cutting itself into wedges:
the sex wedge, dense and sweet
because I have been faithful to one man,
and the hurry-up-and-wake wedge,

my hunger's a white piece of the moon
on fire with cold at the entrance to my throat;
and the dull gray wedge of things I ought to do,
and the purple triangle of laughter, and the angel food

spongy wedge of relationships.
When I think of all these, I swallow my dreams,
the ones suspended in nothing; they go back down
into my dark, lost mind, the knowledge of each one gone

thin as one single hair. I don't remember
where my soul went. And after Persephone returned
to the earth again, her mother asked her, "Well, was it any different?"
and all she could say was, "I thought it was dark down there because

my husband always kept the blinds closed." "Were there animals
there?" her mother asked. Persephone yawned,
shaking her head. "Not that I noticed."
"Shallow," her mother muttered under her breath. "Teenager."

STOP

I have this one dream over and over—
I'm in the back of the audience,
I have to get to the front—
I'm lost, walking through water.

I'm in the back of the audience;
I know the man on the stage—he doesn't make sense.
I'm lost, walking through water—
My ears are clogged up.

I know the man on the stage—he doesn't make sense.
Stroke. Heart attack. He gurgles.
My ears are clogged up.
They're shells without a voice. I don't want to hear him.

Stroke. Heart attack. He gurgles.
He has forgotten his lines. I prompt him. *Tell them your name.*
They're shells without a voice. I don't want to hear him.
Stop, I yell. This hurts.

He has forgotten his lines. I prompt him. *Tell them your name.*
This could be my father, my lover, my best friend;
Stop, I yell. This hurts.
I choke, I sob, I stumble down the aisle.

This could be my father, my lover, my best friend.
I have this one dream over and over—
I choke, I sob, I stumble down the aisle—
I have to get to the front.

WE CAN LAUGH OR CRY

I remember what it's like when we're liquid,
when we slip away from each other
into the vast spaces of our inner pleasures,
and I feel what used to be your body falling into me
like a disembodied steamy presence, and I am flowing out and down
until only my toes are left,
and the only thing which isn't liquid is my neck which is a little stiff,
so I turn my head, your heavy shadow shifts,
the light breaks all over our bodies like musical perfume.

We laugh when we slip away like this:
the light is playing a tune on our hands, the blankets twisted,
the bed looks like it was in an earthquake,
and my legs and thighs feel like wet grass;
we can laugh when we slip away like this,
when our bodies slide until we are dizzy, open and empty,
or we can cry, repeating the endless nightmares of childhood
until we fall asleep, caught in the lethargy
of afternoons without telephones or shopping lists.

You are the kitten who turned into a human being,
I am the bird whose wings came off in the narrow doorway of the morning,
you are the sleek teacher of erotic lessons,
I am the dancer who moves her hands
in a circle of yeses and noes;
I am the poet, you are the poem.
I am the cup, you are the beautiful basket of giggles,
I am the apple, you are the clock whose second hand is missing,
I am the tree, you are the cluster of bananas,
I am the thermostat, you are the washing machine
on the second floor of the apartment building,
you are the onion whose layers are purple,
I am a fork with glistening silver fingers.

DREAMS

When I dreamed my father back into life again,
when I wasn't certain I really loved him,
I felt guilty. Look, I said to my mother,
he's in the living room in his favorite chair,
reading the newspaper. The grayness has gone from his face;
he's laughing at something he's just read.
I could hear the layers of grief and relief
changing places in my mother's voice.
The tablecloth she had been holding in her trembling hands
slipped away like a limp white bird
whose invisible wing had been torn.
I pulled the newspaper out of his unresisting hands
so I could see the color returned to his face,
take him by the shoulders and say
I love you and welcome you back to the room of the living
who never really left.

My fifth lover, who had a dark, worried beauty,
and looked older than his twenty-four years
came to me in my sleep.
He was an ocean of salty water, rolling backwards
into my sweetest river to give me the precious
tang of his salt—and this was after I met you,
and fell in love with you, and told my disbelieving mother we had been
making pledges.
In another dream I felt guilty about,
I plan a murder with an anonymous other,
and wake up shaking in a cold sweat.

In the dream I like best, we make love without touching:
our moment of union unbearably burning
with spirit and loss and one body.
There will be no more guilt when I have left my daytime
self like wrinkled khaki clothes,
and have slid and shivered through my own inner darkness,
and felt free as the fire that started the world,
and fluid as the water that races down high desert hillsides,
making ditches and arroyos where none existed before.

This is what I want to do: be at home
in the valleys of the darkness and on its rough pathways,
and have you follow me when I walk down into myself—
with the wildness of my wildest dream,
and the hardest desert rain we can remember.

From My Eyes

we have given you what we could:
a hazel tint
the color of some fertile strips of land
next to a river—

we shift and flutter,
but the flashy impulse to see
doesn't reach the brain—
it's as simple as that;

we sing to you in a language of missing dots;
we touch your cheek with waters from the ancient
springs of salty water;
we've caught and held dust;

feed us with light—
we're hungry for what we have missed
in our craters of silence and waiting;
we're the parts of you that have opened and flowered the slowest,

we're the deserted, desert parts of you
that will not bloom until another lifetime—
it will take some kind of Hopi spiritual dry farming
for us to sprout images.

we'll come back as feathers,
lizards or a swamp lily;
you'll come back as antennae,
salt, or leftover uranium.

there's nothing wrong with us
that a little time outside the body and another lifetime
on this earth won't cure;
next time around, we won't be connected:

another woman, a woman other than yourself,
will see the moon from the bottom of the arroyo
and weep at the beauty of the light;
she will not stop to think about her eyes.

SHIELD OF LEAD

ACID

All of us wanted
cities: beauty trapped in
interstices, the young with
dark circles around their eyes, the beautiful tired.

Aroma of tar in the desert—
crickets with weakened extremities, an
involuted, melancholy, yellow sky—the skeletal shapes from
dead trees.

Acid is not the name of a
clever, new rock group, but pollution's
insignia etching lines of stress on buildings. The
doomed graffiti from the smog. That

acrid taste, that businessman with
caved-in lungs. That
infrared guard at the gate; those
disheveled layers of air.

Homophobia in a Small Town

I hear the neighbors asking them to leave:
Joe the drunk crawls into their bed,
guys drop in unannounced, to see what spell they weave—

They speak in low voices, making their living room peaceful as Geneva:
"We're just getting ready to eat; could you head
back down a little later?" I hear the neighbors asking them to leave.

They do it with cut wires, with rocks they heave:
a few more hairs turn white on Carmen's head;
guys drop by unannounced to see what spell they weave.

Seven years of cookies baked at Christmas: better to give than to receive;
smashed windows make alchemies of dread:
I hear the neighbors asking them to leave.

Should they stay or move? They weed, they prune, they grieve.
They cut the grass, they garden, they cart away the flowers that are dead.
Guys drop by unannounced to see what spell they weave.

From under barbed wire fences what can they retrieve?
A rancher's talisman, a shield made of lead?
I hear the neighbors asking them to leave.
They drop by unannounced to see what spell they weave.

LOSING MY MOTHER

I lost you before I could talk,
I lost you while I was still a fish,
when my fins were still fins,
and you didn't know my name.

I lost you in the dark.
I lost you because I didn't know your voice yet,
and a dream was dropping me into water, and I didn't
cry out because my father had put his hands
over the mouths of these mermaids.

While you held me, I was losing you;
when I couldn't see your face,
we were lost to each other.

Among the string hammocks and crickets of summer
nights, I was losing you;
when you wailed in despair because I cried
in the nets of fever, you were already going away.

Tell me a story, I said to you, when I was a child,
just one more story about the little girl
who became a little boy, how he got his peepee—
what it was like when you were in high school . . .

But you were restless, waiting for my father.
I lost you to dishes and soapsuds,
my father's foamy beer, his key in the lock,
his hand on the bedroom door, rattling the knob.

You disappeared in his shotglass,
you disappeared in stores; you were there, but not there,
a whirlwind of hands, cleaning the windows,
a woman astringent as cleanser.

You gave up your job for my father and me—
we became your double albatross.
Because you cared for me, I lost your hands to
needles and threads and pins, Girl Scout

troops and cookie sales.
I said your name and longed for you when I was sick,
but you knew I thought you were stupid, my father's nag,
a foolish woman who couldn't carry a tune.

Because I thought you were already gone,
I pushed you away with my toys, my books,
my teachers, my boyfriends. I drank tea
to forget you. At seventeen, I lit incense

which you mistook for marijuana; I let my hair
grow and wore clothes I knew you wouldn't
approve of. I longed for the taste of homemade
french fries and the feel of your scrubbed floors

under my feet, but I didn't say so.
When I really fell in love, I left you for
New Mexico where poor students tracked mud
onto uneven wood floors in winter—
and there was sunshine day after day.

Sex between Friends

That experiment we never finished . . .
Twenty-two. We never did talk
later about what happened:

our tongues swollen with thirst
(from too much salt in the spaghetti)
the three of us kissed.

I held one of her hands
while he tangled in first-time tears and blood—
her long hair spreading over my breastbones.

HER NATURAL CONDITION

They said: we know that darkness is your natural condition,
you won't mind working in a room without a window,
doing your job in an office that needs painting.

This is your inheritance, they said:
the oozing gutters in New York City, the rivers
running under the streets—

you were born without a mouth but were blessed with second sight—
you feel the undersides of people's dreams like weights on your feet,
you will wear heavy shoes and catch yourself on the treadmill of your own sorrow.

You will love eclipses and dim rooms,
sad movies and crazy men;
blinded, you will eat blank bread and hide your eyes.

You will drink fear in your water,
you will hear waltzes from prison camp
playing in your head.

They said cover yourself and don't move,
here's a special stone for your chest,
the spider has made a lattice for your place at the table.

In middle age, she turned her nightmares into slinky dresses,
she talked about changing the color of her hair,
and wearing glitter in it.

She doused her food in murky sauces,
and wrote songs that could be played on the black keys
with only an elbow or one hand.

She chose the raven
because it flew without fear, sometimes lived on garbage,
and made definite music in its rough throat.

She opened her eyes,
she put on onyx-colored boots,
and danced to its music without stumbling.

EMBRACES

1

I embrace the baby in the plastic bag that was found in the dumpster;
from seven miles away, I reach out my hands to it.
I stay up all night with the nurses in intensive care.
I feel the vibrations of suffocation, plastic,
terror and poor planning.

2

I go down into the dream of the mother,
the gasping baby, and the father with a penis
as hard and cold as a diamond.

3

I imagine the mother whose brain was swollen,
I draw the suction cups of her hands
into my electromagnetic field;
my neck is on fire.
I hear the sirens before the mother hears them.

4

I embrace the mice,
the virus on the tips of the tails of the mice,
and because I know they are dangerous,
I pin on my psychic armor.
I make a mask, I wear a mask,
I am a mask, and they are running over me,
and I am running away from them, trying still to be cheerful.

5

I embrace the hopelessness under the floor,
the gray blotched cement before it was painted.
I count the particles of grit under the rug,
the places where the nails were—
I bless them, walking in my slippered feet,
calmly counting holes as the temperature drops.

6
I embrace the cold. I get into bed with my shoes on,
I read about Nazis.
I say their hearts were broken,
just as their fathers' hearts were broken,
and my throat tightens as I say
these words softly, and my words are a fog, are a fog
that I breathe in along with the cold.

7
I take a deep breath, knowing that the shifting dark is mine;
I let it in, and it crouches over me,
in a liquid motion of shadows.

8
I like the dark better than mice,
more than hopelessness, more than the baby
whose heart is beating wildly.

9
I am a friend to the dark.
I am the dark that wants me.
In my sleep, I am the universe's dark cheese,
standing alone;
I hold onto myself, I embrace myself throughout the night.

To Think about Tiredness
You Have to Let Yourself Go Underground

They were the women who did two and three things at once—
they taught children and patted heads and typed a hundred
words per minute, they oversaw departments, they trained
employees, they painted and sold their pictures,
they built houses and graduated with honors;
they weren't supposed to bump into things and collapse
from overworking and have trouble concentrating, but they did.
They weren't supposed to get a flu,
and never quite recover, but they did;
they weren't programmed to stay in bed all day and be jelly,
their wills at their feet like some 27-year-old declawed cat
from childhood, but this is what happened.

To think about tiredness, you have to let yourself go underground,
because tiredness is forbidden to people in this culture;
remember the air with its hundred hammers,
fluorescent lights, formaldehyde gases,
exhaust fumes touching us like wisps of dangerous hair,
eaux de cologne made from petroleum products,
a smog haze hanging over hundred-story buildings,
women who were bred to take small steps, women who were told
nothing happened, this has no name, it's a cheap rubber glove,
it doesn't hurt, you have no name; keep it a secret,
you made it all up, it's all in your head,
be quiet, lie down, don't move, it never happened,
it never really happened.

This poem is for all the women who have had
something irretrievably lost:
for my friend Leona who can't eat whipped cream anymore,
because of her damaged immune system, for Sheila
who can eat only 11 foods because she's allergic
to the rest, for women who have aluminum foil

on their shelves, because of plastic and particle board
and electrical impulses that make them sick,
for Sima who lived outdoors and slept in her car
for half a year because of pesticides buried under her house—
I want them to pay attention, I want them to rave,
scream, and croak from that witch's power that lives in their chest;
I want us to put out our cigarettes,
and stop working in buildings that make us sick;
I want for those women to find friends who will sit with them
without wearing scents themselves and never, never tell them that they're crazy.

I want to give them bullets made of purest materials,
horses full of cosmic wires who will rock them
through the mountains and take them to the untethered stars,
I want to give them fire, dreams of fire,
rushes of energy and each one a valley
on the moon where she can wrap herself in silence,
and I want each of these women to have air
that she can breathe that is empty and crystalline,
her own air, enough air for all of us.

For Ai

You gave me permission
to insert jagged glass into centers of my lyrics,

to allow dark bruises to break out on the page,
to sew the memories of spittle and ugly exchanges

into the beginnings and endings of poems. In your books
I inhaled the musky scents of killers,

I looked at the swollen lips of Danger
and drew the routes to confusion and ecstasy

on red maps inside my cheeks.
Because you saw death spilling out of pineapples,

escaping into sugarcane,
and shaking the bodies of old pickup trucks,

I let my father enter the house,
kick through a door,

and leave the mark of his foot in the wood.
I could write about my mother,

chasing me with a hairbrush,
and the rooms where I thought of suicide in 1965.

Tonight I write your name at the top of this page.
Beneath my fingers, the letters disappear—

it's as though you swallowed your voice
at the beginning of a reading,

and the audience can hear nothing but your cough
into a black, chipped cup.

Don't leave me, I tell you.
(Your eyes are dark shards in your face.)

You're the woman who can walk on fire,
burn your feet, and walk on fire again.

GRIEVING

I've been with men who needed to do some grieving:
their sobs come out hard and lumpy
like a terrible gravy stuck in their throats—
lovers on the phone
or in a room with the shades drawn and the door closed—

or else in a public place such as a gymnasium
where they have felt they would be safe—
usually it's the loss of their mothers
that brings up this thick grief from the belly to the eyes.

Once in Alamogordo there was the time that my friend Mary's friend Dan
cried in the middle of the marching band concert;
amid raucous cheers, I heard him sniffling,
a sadness as pure and empty as white flour
hovering around his stooped southern New Mexico back.
I never told his wife Helen,
a Christian lady from the islands,
a woman with a lilting voice and chapped, busy little hands.
It was our secret, this grieving,
as the other Air Force mothers and fathers cheered.

New York Sestina

To survive in New York, she has to be a fast-talking woman,
her second skin made of leather, able to repel knives,
able to type in her sleep, her mouth
reinforced with glass from twenty broken windows,
with a body she can fold and unfold, with a body she can hide in on the subway,
a throat that can open and close itself when terror

strikes, and a voice laced with steel the color of terror,
that bloodless color that could make her an old woman
before her time. All night she is homeless and rocked on the subway,
all night, she aches, her neck full of knives;
she thinks of suicides: the friends who jumped out of windows,
the banker who spat all the teeth from his mouth

decorating the street in bright red from his mouth,
the computer programmer who heard voices, who heard terror
talking gibberish in his head and jumped, leaving his window
wide open; if only he had been a woman.
He would have tucked terror into his pocket like a
handkerchief; he would have known that knives
are what keeps the back straight, flickering all night under the subway.

She's a waitress who starts screaming when angels fill the subway.
Wanting to forget their pale bodies, she covers her mouth
with her hand, while her ears fill up with the rattle of knives:
they are under her, singing to terror.
She imagines them in the belly of the city, like mercury poison to a woman
who likes to grow flowers in boxes in her apartment windows.

Everything she knows about beauty shimmers in the broken windows
that repeat themselves in car after car of the subway.
What she sees makes no sense, so she is the woman
who covers her eyes and closes her mouth.
Upstairs people sleep on sacks and cardboard; their terror
slides toward her like the animal magnetism of knives

in the hands of teenage boys who know their knives
the way she knows grief at a hundred windows
yawning open in 30 degrees of terror.
Fear follows her across the street and down the steps to the next subway
where cries for help fill her mouth
with serum of nightmare, and if she is the fast-talking woman

she wanted to be, she will turn her words into knives,
she will throw them all over the subway,
she will break windows with her scream, and the mouth
of her enemy will quiver with terror.
Such is the power of this screaming woman.

A Strange Taste on My Tongue

JUDY

i hadn't thought about you in years
until a poet at a reading mentioned
a woman with red hair i think how we
drank wine in your car drove to albuquerque
danced together
you wanted me in your

bed thought i was
ripe for your small rough hands
even after my arid refusal we could have
wept we could have
embraced standing in the steaming weather
of your greenhouse we could have talked and
rested until we felt better until we stopped
talking until we might have heard
each other sleeping

Plum Tea in the Desert

1
After afternoon sleep,
the water has just started to boil.

2
Flavors swirl on my tongue—
fruit tart, sugar white,
the wild familiar patina of sweetness,
shielding me from despair.

3
I drink to the smooth, green skins of the fruit
shining in the leaves, the dusty Sunday yards
where we have picked
several notes in C-sharp major in the vibrato
of the flute; we were lonely,
picking plums in a boom town, longing to escape the desert.

4
I drink so the jays will call to each other,
the junipers have new growth
after the June beetle is finished.
I drink to dreams, blue mussel shells,
the plums rolling toward each other while still clinging
to the tree, the wind shaking the tree; by next month,
the plums will ripen, darkening, darkening.
Here in the desert, we can do what we want in spite of the dust.

5

Your hair has gotten thinner,
but it still flies, falls into your eyes;
I think of hugging you, the bones in your back,
begging to be counted; let's go upstairs, I say,
let me count them there. A tart song spins
from me to you. I hear the stillness inside the wind.

6

The jays call to each other,
the plums tremble and hold on.
I bring you desire:
a flute full of colors.

7

The girl that I was
still lives in my slender fingers.

NIGHTCHOIR

As a child, I walked on the heels of shadows;
I kept close to shadows,
quietly serving my dolls tea in shells.
Good night, I said to each doll, touching each cold hand.

I had dreams where I moved with absolute freedom,
glided among the soldiers speaking Latin,
and a lion jumped out of the television to save my life.
Don't sing too loud, I said to the choir in my head.

Don't talk too loud or the whiskey glasses will hear.
I want a playfather, I want a hero, I said
to myself, and the choir sang, and I gave them the chorus
line after line. The choir swelled. I whispered

the words faster and faster. Getting up to pee,
I walked through shadownets.
My mother had taken away the spiderwebs,
and the empty bodies of dead crickets.

There were still the sounds of locusts in the trees in the yard
that could make me cry.
I talked to the Lone Ranger
while I listened to the choir.

Be my playfather, my hero in white boots.
I held myself still until the choir finished singing
the Hallelujah Chorus. Trumpets dissolved
into "Rain on the Roof," on the piano,

an ugly song that I played for my real father
when we were living in Johnstown, PA,
in the house with the glider on the front porch,
when I was in third grade.

EMPTINESS

From the time I was two,
I knew and hated emptiness:

the salt water taffy box
full of nothing on my lap,

my father's absent look,
his place at the table,

on Friday nights.
I learned to fear emptiness in my stomach,

I talked to it,
I shooed it away with my hand.

I was fascinated with it, the wild patterns
of hissing static on the air

when radio stations ended their broadcast day,
the moment of silence after Joan Baez stopped singing.

My date calendar in high school was always blank
except for fantasy musicians

like Dave Van Ronk who growled in my ear
and wouldn't let me sleep.

When I was twenty-three, I loved a man who was thin
and ate nothing but rice. He said his belly was a

washing machine that he had to keep clean.
The night I took him to the hospital, I spent

two of my last quarters to buy us slices of pizza;
I made him eat his right on the street.

It was warm and thin and tasteless,
and I knew we were chewing and swallowing emptiness.

It wasn't until I held emptiness in my arms,
and smelled its breath full of dust and water,

that I loved it in the middle of a mountain trail
when it started to pour rain and we had to walk down for hours

through wet leaves and dark soil. That was when emptiness
opened me and I gathered bags of it

and brought them home and set them out to dry
like apricots in the dusty backyard.

DRY ICE

Age burns the extra flesh off your hands,
making hollows in your cheeks,
accentuating your nose.

There's a picture of you,
standing beside your Austin Healy,
a red car that can go 95 miles per hour:

you look sleek, some of your friends have said,
like a movie star, wearing a suit and tie,
your chest plump with prosperity.

Now you hold an angel in your thin hands,
an angel disguised as a bird,
pecking at your palm,

etching mysterious patterns
among the lines of your life.
When you love me,

your fingers are fierce
with angelic dry ice.
They open me into tears

the way a beautiful dream can do.
I touch your cheeks and feel each bone,
and weep without words

for what the angel was permitted to steal from you.
You are my movie star, I tell you,
before you fall asleep, light on my shoulder.

Interview with My Mother's Suitor

Will you help her paint her house every year?
Will you take out the trash without being asked?
Will you wipe your feet, and hang up your coat?
Will you make her laugh when her back is hurting?

Are you the one who will bring her breakfast in bed?
Will you send her 300 roses for the next 300 days,
whether she loves you or not?

Will you look at her hair and tell her that each strand,
each dyed-brown strand, is like a lollipop?

Will you say you have always loved older women?

Will you lay your hands on her and say
I have just cured you of codependency because I love you?
Will you go to the Bahamas together?
Will you tell her neither of you ever has to work again?

Will you give her a back rub
every time she gives you one, every time she wants one,
whenever the twilight is full of the footsteps of sanguine elves?
Will you let her tell you her story
as many times as she needs to, even though her voice

beats on your vulnerable ears like a rain full of cold pennies?

Seeing

one of the things she doesn't like about not seeing
is that she misses things that some other people don't miss
at Jemez Springs for instance where she and a friend were bathing naked,
the guys sitting on the edge of the pond
looked at her, but she couldn't see them,
she soaked in that hot water,
sleepy from so much wine and cheese,
her feet settled into the sand
and she felt she belonged to the wetness and the frothy water
as much as those guys who laughed to themselves,
and whose skin, hair, shirts, and belts would remain unknown to her
because she wouldn't go up to them and say, now fair is fair,
let me touch the places on your bodies
that you try to hide,
it's my turn—don't draw back, or sit on your hands—
let me count your rings, your scars
the hairs coming from your nose,
welcome my curious hand,
let yourselves be undone not by love
but by my fingers looking for careless pleasures
we don't care for each other yet...
i'm a woman whose hands want to surround and capture everything,
let me electrify your neck with my questioning fingers;
i'm going to pull your ears gently,
we don't have to talk,
i left my favorite words on the edge of the water with my clothes.

TALKING WITH MY DEAD FATHER

When you died, I was fifteen. I said please have a
resurrection like Jesus did; rise from my dream,
climbing up the front steps, wearing your bland
"Evening in the Moonlight" face.

Please return from the bars alone, empty-handed,
closing the door with a whisper of your fingers,
sit on the footstool of your favorite chair—
I have fallen asleep in the chair itself,

waiting for the reconstituted you, after hours of jazz
on the radio and my mother's snoring in the quiet house.
Tell me what you learned about oxygen, your broken heart,
the ambulance that took you away,

and the blaze of dark stars where you burned
until I called you back with my raw dream longing
Your going made me an atheist. The kids still walking
to Sunday school spoke jingles and bubble gum.

I loved Genet, Camus, and you,
and there was no God when I sat in my teenage skin
and wanted you back the way later I would
want to sit under a juniper and play my dreams like

desert light. Touch my knee and look into my eyes
the way you never did, singing me notes from a thousand
stars. Rock out in your ghostness. Cradle me in your
look. Give me what you brought me

from the other side of your sleep. Tell me one secret
from the gaggle of your failures. Tell me with words
and no-words, using your dead head,
tell me a story about your other body.

LATE

Late for your party;
notice our secret smiles—
Santa Fe lovers.

LETTER TO PABLO NERUDA

It is new for me to write to a dead male poet;
usually it's women I admire:

their gritty softness as they struggle,
how they fight, cry, risk their lives—

Karen Silkwood, Frida Kahlo, Marie Curie.
Yet it's you who come to me in my half-sleep,

you who loved your country as you loved women,
obsessively, indiscriminately, constantly.

You were tortured and killed.
And I would kill for one of your lines,

the way your lines sink and flow into the consciousness.
Images of guerrillas, mountains,

talking rivers and death.
Faithless to one, you were faithful to many,

embracing hermanos y hermanas
and starvation because of his white glistening body and acute right angles.

You loved water and darkness, and so do I;
you lived on very little, and so could I

for the kiss of some of your perfect lines on my palms,
making my fingers move in confident silence, writing of love.

If I could find you I would say, bésame, y dígame,
solamente una vez; that would be enough for me, bastante.

READING BRAILLE

It wasn't my stomach that liked to read, but those socially acceptable parts:
the orderly hands, the thin shapely wrists, the neck with its pockets of deceit,
the mouth with its tiny partitions, the eyes with their flower centers;
it wasn't the nose, it wasn't the legs in their sheaths of skin,

the ankle bones that protruded—it was the head,
the brain with its secret lobes,
the spine with its little curvatures;
all of these parts read and read when I was a child,
these parts with their clear black and white English names, not

la cabeza, o las manos o los ojos,
o la cara o las piedras o la primavera blanca;
not the knee but the fingertips, not the thigh but the petite ear;
all of me sank into my lap where the book was;
they talked about the ambulance coming, about my great aunts who were sick,
my mother talked on the phone about what the hairdresser said about sex,
my father answered my mother in mumbled syllables over the blare of the
 television,
and I sat very still on the couch so they wouldn't notice
that I hadn't gone to bed;

I read and dreamed of wild, dark places near the water,
pearl divers who dove for pearls and had seaweed on their arms;
I was not at home in my body then,
and I read until my fingers were raw, and there were
words racing through my head and I didn't have to talk
or ask too many questions.
I loved the quiet in the house when my parents were sleeping—
when I was alone with my hands.

THE STRUGGLE

The poems live in their garden—
Persephone has planted a row of pomegranate seeds
around the edge, they grow into tall trees,
they have thorns. I can't get into the garden
by ordinary means, so I weep, I scratch myself,
I promise to give up my job and my car
for the poems, I sneak up behind Persephone
and cut off the end of her ponytail;
I do it with my sharp, Japanese scissors.

I cut my index fingers, I drip blood
onto Persephone's thin right shoulder, and then I
steal away.
I send the poet Ai a telegram, it reads:
I'VE CUT MYSELF FOR POETRY,
I WANT TO BE IN YOUR NEXT BOOK.
I go to several secondhand stores, I buy up
all the secondhand eight-track cassettes I
can find, I unravel the tapes and let them go
in a shiny circle around the trees around the garden.
I start walking and hearing my feet shushing through the strands of tape
as though they were leaves;
as though I were doing a walking meditation,
my feet develop a slow, steady rhythm;

I ask the trees to let me in,
I tell the poems that I will continue to not clean house,
that I will make up a special song for each tree,
that I will sing to all the trees everyday, and water
them faithfully,
that I will only take a poem from the garden
when my mouth feels raw, my hands shake,
and I don't have anything clever to say.

The poems want a woman whose speech is slurred,
one who has stumbled and fallen,
and slept too long and forgotten exactly what she
should be doing.
They want a woman who will make her own poems
out of hair, thorns, and sweat;
they will come to her as long as she is living in exile
on what she can grow for herself.

I have wanted to be that woman.

LISTENING FOR CACTUS

I have always listened for the sound at the end of silence,
the notes after the piece ends:

I sit among cholla for hours,
my face cracking with sunburn;

they must talk to each other,
their seeds speaking as they brush together.

I put my ear on the earth,
listening for vibrations;

opening the window in the loft,
I hear what might be the earth's mysterious hum.

Under my stick,
the cholla make tuneless tunes,

a musical instrument from the moon.
Listening for cactus was a little like looking for God

when I was fifteen,
like looking for a good lover when I was twenty-one.

God rolls through the wind,
and lands in the dust

that hurts in the corners of my eyes.
There must be a reason why I sit,

day after day, my clothing stiff with waiting,
my hands disconnected from each other.

I have always listened for the sound at the end of silence,
the notes after the piece ends.

When I'm Eating Chocolate and Writing

The angels dance and eat shells of
gold loose light.

In this dream I can write without moving,
the fire putting petals over my closed eyes.

The sweet words stick in my teeth,
caramels my tongue knows, and explode again
 and again.

My heart is a dark chocolate of longing
made by my parents when they wanted to cool off

after melting. It was February, the heat was almost off:
1946 when everybody thought there would be a perfect

future for them. Thinking of so many Jews, Germans,
Russians dead before them, my parents burrowed in,

and held on. While they slept, smoked,
woke again and complained, I drifted down through my

shelter and heard polkas, and my father laughing with his friends.
The angels tell me to lie still so the fire will leap

over and read the words on my chest. The teakettle steams.
I murmur yes, then sit up to ask if I will be famous.

They push me back into blankets, painting my cheeks
with cherry-colored lines, and they say WRITE.

I climb up uneven, lumpy chocolate slopes,
my bare feet slipping backwards, my mouth full

of Swiss almond courage and sleep. My mother has
said this life may be too much for me, too tiring.

Already my father's body has been losing itself in a
cemetery whose address I don't know. It has been

32 years since my mother and I heard his voice
and never told him to his face we thought he was hopeless.

Because thinking of him is almost too much for me, I beg
the angels to bring me water. Being made of teenage

energy, they prop me up and bring me a notebook
full of white silk pages.

They whisper I will outlive my mother
and eat chocolate till my dying day.

WILD PEARS

wild in sunlight knobby and hard
in our hands they fall from the trees barely touched they are
lumpy and sweet sunwarmed smelling like wine under-
foot we walk on
disconnected stems our feet pressing ripeness into dirt we

pick in Galisteo village quietness taking
enough to fill your hat taking some from every tree they
are a strange taste on my tongue as
rough and pungent as my
smallest longing

TENDERNESS

I wake up slowly from an ample Saturday morning sleep,
I smell the soft skin on the backs of my hands
where the invisible kernels of tenderness are buried,
and their fragrance drifts out to my nose,
and they smell the way sleep smells.

When I was four years old, I asked my father
what a policeman would do
if I played my record player all night and wouldn't go to bed;
he'll spank you, my father said.
I wondered if policemen ever became tender,
I lay in bed all night thinking about Nazis:
did they ever rescue little girls or did they
throw them into the incinerator?
Surely one of those men in hard leather boots
would lift me up and embrace me the way a father was supposed to do.

I remember the time I washed your hair, rubbing in the shampoo,
keeping the sudsy hair away from your eyes:
I could bang your head on the bottom of the sink again and again;
nobody would find me out for a long time,
but I thought of the man holding me delicately
against his leather jacket, his whiskers on my neck,
so I moved your head under the tepid water, and you never questioned
the chemistry of my tenderness.

You brush my cheek like a pinon jay taking
flight for the first time,
I cover your eyes and your nose with my hands, and the top of your mouth,
to keep the sun off, I close my eyes and lean
into the wooden side of the house,
I move my hand down, I encircle your cool wrist with my fingers.

SPELLS

Untitled

Over the pine trees
those solitary ravens
are shafts of black silk.

Our First House

let's build here:
among russian olives
with sage bushes in our yard
a house as tall and narrow as a tree
with the river rushing past our bedroom window
we'll sway together in narrow rooms
whispering to each other
a deep quiet in our eyes
in the night we'll smell wild roses
we'll sit by the irrigation ditch
sifting the black soil between our fingers
we'll watch the moon we'll
walk along the Animas collecting wood
we'll lie in dry leaves
dreaming that a sadness wonderful as mountains
is floating and brooding over our land
turning us gray and silver as old logs

HEROIN

My white powder
shines on bones in arroyos,
on stones from underground,
on the skulls of long-dead
cattle in the valley.

My drugs are lichen
in the stones of the wall,
the lightning striking
irregular slashes in the wood,
rabbits leaping from behind cactus then disappearing,
the nighthawk divebombing.

FOR MRS. GREEN MUMMY

mrs. green mummy,
you look at me
from inside your bandaged face,
you don't have arms,
i write to you using my tongue and lips
instead of a stylus—
you've been swaddled, propped up,
wrapped in the silent clothing of people and windows that have died—

Death comes out of your head and turns my head,
i hear my gritty neck crack,
feel my knuckles bleed, i dread
an accident where i get stuck in a car
whose seats collapse into each other and crunch me in half;
Death on top of your no-face keeps turning:
ferns sprout from your hips,
tough white muscles
burst and arch up through your green and yellow legs,
stiff children, metallic, spindled,
fractured children who don't speak either
come out through your breasts,
and their auras bounce in the air,
and everybody who sees them, especially those
who avoided them in the past
will gasp,
and foaming yellow letters
will come out of their mouths

dizzy, crooked, horny-fingered Death
will stop pinching the bottoms of teenage girls,
and the leaves and rough seams from your hips will shimmer,
and people will shut their eyes and fall into trances,
as you slide on your bound, withered feet
out of the city
and into an empty river bed forever

A Spell for My Sisters in Bosnia

There will be no more rapes.
No more women being forced to do anything against their will.
There will be no more terrible tearing of clothing,
no more bruises, no more women lying in the mud
after winter rains.

There will be no more soldiers
raping wives in front of their husbands,
no more neighbors raping neighbors,
no more children watching the penises of soldiers,
no more mothers nursing dead babies.

There will be no more soldiers dragging a woman to their general,
and because she is still speaking from her own power,
she asks the general, would you rape your sister,
if I were your sister, would you rape me?—
and he releases her.

There will be no more generals.
There will be no more soldiers.
There will be no more politicians,
no more oceans full of oil,
no more grapes full of pesticides,
canisters full of poisonous gases,
no more men who are powerless,
no more men who are angry,
no more men who are angry.

ANOTHER MOTHER

There is a secret doorway
that your breath stopped for—

you were between here and there
for about 48 hours.

In a dream you called my name,
and I answered "I'm here,"

in a language I hadn't used
since aged two.

I watched the life slide out of your eyes,
and we said goodbye with our hands.

Don't worry, I told you,
although my skull is surprisingly fragile,

I am as strong as the silt in rivers,
as bright as the parrot that lives to be a hundred,

as sound and boring as gold coins,
I can live as long as licorice whips.

But without your harsh chirp and bitter bite,
I wonder some days why I would want to.

In my waking dream in the middle of the night,
your ashes are sticking to leaves

and blowing back and back onto our hands,
and there is nothing else we can do but continue.

Because you are gone, I long for a compañera,
una mujer con los de silencio,

another mother—and the tea leaves in the blue cup
will rest in a pattern of luck just for me.

Where I Come From

My feet come from Ireland;
slender-toed and narrow-heeled,
they were fingers in another life, plucking the Irish harp.

My legs come from the soft, dank, rainy parts
of the German side of the family,
from my mother's clan, lonely and laconic,
from a tough stalk in the fields that could not be broken.

My hips are from Pittsburgh, Pennsylvania,
from my 5'2" mother who gave up coffee and cigarettes at the same time,
my belly came from Johnstown, and from my father
who made it full of hunger that nothing could satisfy,

and the belly button is a deep hole from my mother's sorrow,
and the underskin of my wrists from the bridge my parents
made for me with their bodies, strong and soft;
my palms come from East Liberty, and my poet's voice

began in an unmarked county on a moist Irish map
as did my darkest center. My office voice
belongs in Abington, PA, a suburb where in high-
school, steak and french fries were my favorite foods.

My back came from a German winter where my mother's people
stared into a gray sky for months.
My breasts were born in the spring when I was 29,
and had a crush on a guy who was 19 and in love

with too many of the wrong women.
My hair comes from my Aunt Nunna's
sewing basket of dreams, and all the dreams of the family
came out of the dark mushrooms where people barely spoke.

The mushrooms of our torment
came from the left hand of death; our silences come
from the goddess of lost things, the patron saint of broken
speech; my toes feel for her in the dark.

SURPRISE

Mother, more cooperative
after death than during life,
your ashes turn the stream white.

When You Die

When you die,
leave me all your favorite words
in invisible boxes.

Carve them out on pieces of shell
so I can find them and read them.
Leave me your glasses

so I can see your ghost in the mirror.
We'll call him Vagiño,
after the roguishly sensual

South American hero in Jorge Amado's novel
who came back to haunt his widow

leaping all over her like a monkey,
tickling her and her dignified second husband
as he made love to her, covering her

with the sheets, lifting them tent-like
over his great cold back.
You'll be my Vagiño,

leaving spots of warmth
on each breast and each hip,
my saint, my best lover, my ghost,

who covers me with flowers,
and wet kisses smelling of crocuses.
Leave me your hands resting lightly on my shoulders.

Leave me your laugh to protect me
when I'm out on the street at night by myself.
Give me your sense of direction

so I never get lost in the desert.
When you die, leave me your recipes for bread,
baked fish, and stuffed cabbage,

your good big teeth and nails
for opening bottles and cans,
your eyes for finding bargains.

Lend me your strong bones
for carrying heavy objects;
while I sleep, put their strength into my back.

Leave me your power to dream and remember—
all the details, lurid and delicate: the thieves,
the fast cars, the subway platforms, the police chasing

you, mad shysters shooting holes through your door—
let me into these dreams so I can follow you,
so we can run together and never have to lose each other.

Returning

1

At thirty, I returned in tears;
in the woods outside of Eugene,
we were full of blackberries and squeaky farmers' cheese,
we made tapes of the ocean, and the stream,
and the fire crackling, and the gulls crying high
above the driftwood pilings.

2

I returned to the desert, to ambition,
longing to work, longing to take my place
with the ones who were serious;
said goodbye to the fitful star of leisure,
took on the flat plane of an office,
oil field workers waiting to be told what to do after injury.

3

In dreams I returned to old lovers,
told them things they had forgotten,
and what I loved and hated about their sex.

4

I revised the tapestry with my parents on it;
I grieved them and I told them all this could be forgiven
and changed into another drama altogether.
I said goodbye to how they fought, how we could not talk
to each other, how we were lonely for each other.

5

Every year since forty,
I return a little more to myself;
I get closer to the young child who was left behind,
the one who was looked at too much and who fled;
we like to sit on a low stone wall,
our feet flat on the ground;
these words are for her,
as she sings and weeps and looks out:
let's stay in the world for the hummingbirds,
for eggs and apples and friends we might make,
for the stories we will tell, and the stones we will hold.
I am here with you,
and I won't forget you.

About the Author

Mary McGinnis has made her home in New Mexico since 1972, where she discovered more about her poetic voice as well as her connection with the desert, its stones, dust, and occasional water. She writes in desert quietness and fresh air whenever possible. Her chap book, *Private Stories on Demand*, was published in 1988. *Listening For Cactus* is her first full-length collection. McGinnis has given many readings at various bookstores, galleries and cafés in Philadelphia, Albuquerque, Taos, and Santa Fe. She juggles her time between counseling and training people with disabilities to do peer counseling, and the intricate web of writing and rewriting. She thrives on magic, poetry, and good, strong caffeinated tea.

An audio cassette of the author reading the entire book is available from the publisher for $5.95 plus $3.50 for shipping and handling.

About the Press

Sherman Asher Publishing, an independent press established in 1994, is dedicated to changing the world one book at a time. We are committed to the power of truth and the craft of language expressed by publishing fine poetry, books on writing, and other books we love. You can play a role. Bring the gift of poetry into your life and the lives of others. Attend readings, teach classes, support your local bookstore, and buy poetry.

OTHER FINE BOOKS FROM SHERMAN ASHER PUBLISHING

POEMS ALONG THE PATH, Judith Rafaela, ISBN: 0-9644196-0-2, $10.00, paperback, 48 pages. *From an Oklahoma childhood to Kathmandu cafés Rafaela writes as physician, wife, traveler and passionate Jew.*

A PRESENCE OF ANGELS, Judyth Hill, ISBN: 0-9644196-1-0, $12.00, paperback, 72 pages. *Collected poems filled with the luminous presence of muses and angels, laughter and insight.*

WRITTEN WITH A SPOON, A POET'S COOKBOOK, edited by Nancy Fay & Judith Rafaela, ISBN: 0-9644196-2-9, $18.00, paperback, 200 pages. *Food and verse on facing pages create this exciting collection of family recipes and original poems.*

MEN NEED SPACE, Judyth Hill, ISBN: 0-9644196-4-5, $12.00, paperback, 72 pages. *These poems, a tribute to growth in relationships and writing, move through expectation, disillusion, and disintegration, to seeing and loving people as they really are.*

MOVIES IN THE MIND: HOW TO BUILD A SHORT STORY, Colleen Mariah Rae, ISBN: 0-9644196-5-3, $14.95, paperback, 142 pages. *A Writer's Digest Book Club Selection,* MOVIES IN THE MIND *brings Rae's celebrated workshops to the page. A must for every writer of fiction.*

THE XY FILES, POEMS ON THE MALE EXPERIENCE, edited by Fay & Rafaela, ISBN: 0-9644196-6-1, $18.00, 200 pages. *Illustrated with photos and line art, this collection shines the spotlight of poetic truth on the diversity and richness of the lives of men.* **February 1997**

ORDER TODAY!

Our books are available at fine book stores or directly from the publisher at 1-800-474-1543.